Once Imagined

Library and Archives Canada Cataloguing in Publication

Hendry, M. (Michelle), 1969-, author, artist
 Once imagined : an artist's journey through abandoned
places / M. Hendry.

Includes bibliographical references and index.
Issued in print and electronic formats.
ISBN 978-1-77161-281-4 (softcover)

1. Muskoka (Ont. : District municipality)--History.
2. Muskoka (Ont. : District municipality)--Buildings,
structures, etc. 3. Muskoka (Ont. : District municipality)--In
art. 4. Abandoned buildings--Ontario--Muskoka (District
municipality). I. Title.

FC3095.M88H45 2017 971.3'16 C2017-903838-9

Published by Mosaic Press, Oakville, Ontario, Canada, 2017.

MOSAIC PRESS, Publishers

Printed and Bound in Canada

Cover Design M.Hendry / Interior Design by Courtney Blok

We acknowledge the Ontario Arts Council
for their support of our publishing program

We acknowledge the Ontario Media Development Corporation
for their support of our publishing program

MOSAIC PRESS
1252 Speers Road, Units 1 & 2
Oakville, Ontario L6L 5N9
phone: (905) 825-2130

info@mosaic-press.com

Once Imagined

An Artist's Journey Through Abandoned Places

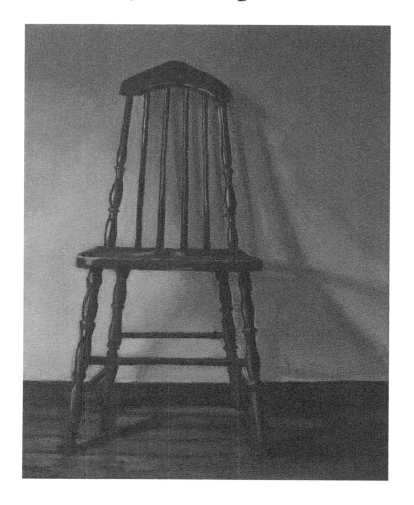

M.HENDRY

mosaicPRESS

To Jeff

For coming with me
down every road,
no matter how rough

Table of Contents

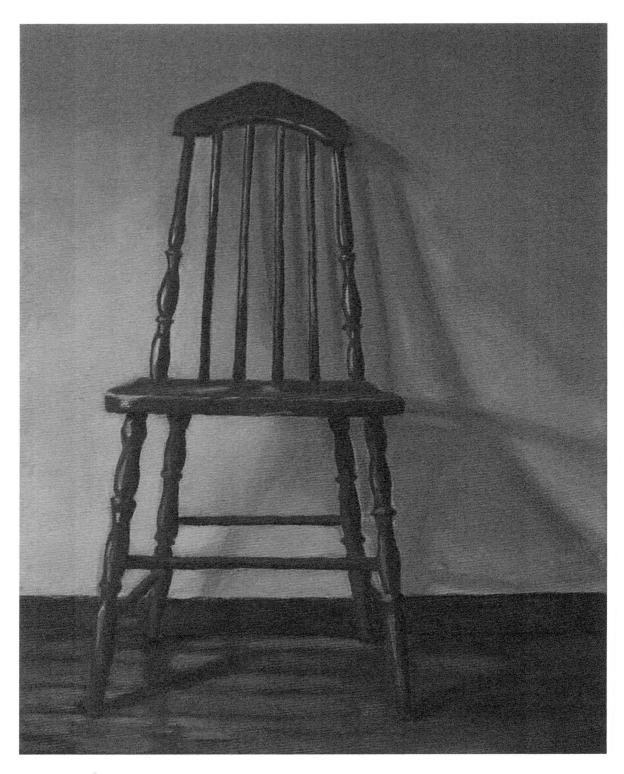

Red Chair, 2010
acrylic on canvas
10"x8"
Private Collection

Foreword

The Optimistic Realism of a Participant Observer

In this unique book, Michelle Hendry realizes with artful grace her long-held desire to revivify memories from her childhood encounters with remarkable yet abandoned places in Canada's far-famed Muskoka District.

Here is attention to detail, yet impressionistic with a potency that transcends small features.

Here is created a mood that is of another time and place, yet is fixed in the rural realities of present day Muskoka's out-of-the-way corners.

Here is, like dawn or dusk, that twilight of places, and of people who called them home – scenes captured in the last remaining light of time, places whose future is all behind them, yet which even so are now indelibly preserved for posterity.

In these portraits of place, humans are not seen, yet they are present – embodied in what they dreamt, created, and gave themselves to through life's richness and rawness. They are memorialized even more through finely crafted accounts of the artist's encounters, in person and through photographs, with the humans who passed through and left their now fading mark. In these sagas, the artist's words equally capture her same gift of engagement she displays in her paintings – the optimistic realism of a participant observer.

In *Once Imagined*, Michelle Hendry's blended words and art enable these treasures to live on, like a song that continues even after the singer is dead.

J. Patrick Boyer
Fourth generation Muskokan
Muskoka historian and writer

1

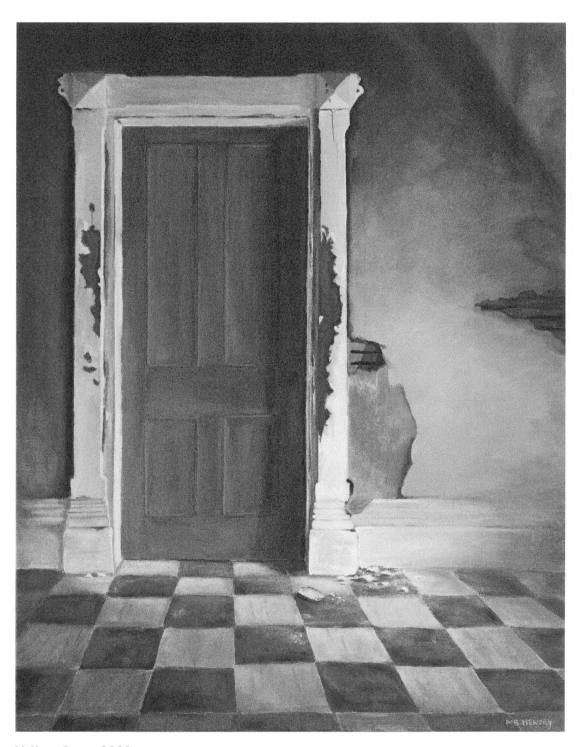

Yellow Door, 2009
acrylic on canvas
14"x18"
Private Collection

Preface

In early 2008, my first solo exhibition in Gravenhurst, Ontario was only a few months away and I was starting to panic. No series was emerging. What was I going to paint? What did I have to say that nobody else was already saying?

I went for a drive to clear my head, wandered the back roads east of Gravenhurst and Bracebridge in search of – something. I drove for hours along a narrow dirt road cut like a scar through the dense bush, broken by snow-covered swamps, small farms and tiny homesteads. Nothing. As evening approached, the crisp -22C chill sank into deep January cold. I paused to enjoy the sunset and found myself in front of an open field and abandoned farmhouse. Everything slowed down.

Cobalt blues chased twilight and swallowed the last remaining warmth of sunset. Winter's shroud covered the landscape, broken only by a few evergreens and this greying house. The season's silence was as deep as the snow. Frozen white curtains concealed the kitchen walls. A line of measuring cups left as if waiting to measure the weight and volume of time.

The painting "Twilight" (see Chapter 1) was not only the beginning of a series of paintings, it initiated a spiritual journey through abandoned spaces and a quest to uncover the stories of life before the descent of stillness and decay.

National Geographic Traveler named Muskoka as one of its "must see" places in the world for 2012. For well over a century, the pristine lakes and rivers, the lush pine forests and granite have attracted tourists hungry for adventure and in search of a break from the urban economic engines of the American Midwest and Southern Ontario. While modes of transportation to the region have transformed from trains and steamships to highways, the reasons for coming haven't changed.

My family started coming to Muskoka in the mid-1960s. My earliest memories were of two small 'summer only' cottages with electricity, but no phone. My father and grandfather were both builders, so we had the luxury of indoor plumbing. The lakes were far less populated back then and it was not uncommon to find long-abandoned cottages, homes and even hotels on the rocky shores.

...a derelict frame building emerged from the dark shadows of the Muskoka bush like a cinematic haunted house.

When I was around six years old, my family would often cruise along the shores of Lakes Joseph and Rosseau in our yellow Sea Ray boat. We drifted slowly through green-gold pine pollen that floats on top of the water like oil. I sat on edge of the fiberglass bow, holding tightly to the metal railing and peering over to see my reflection. My feet just touched the water. Alternating pockets of spring-cooled and sun-warmed water passed playfully around my toes, leaving them yellow with pollen.

On one trip, a derelict frame building emerged from the dark shadows of the Muskoka bush like a cinematic haunted house. The granite rose steeply to the crumbling verandah of the long-abandoned cottage. I was too young to explore the structure, but my father decided to have a look and brought the boat to shore. My imagination ran wild while he disappeared from view and when I saw him climbing back down to the shore, I peppered him with questions about what he had seen: broken windows, rotting floors and a rusting bed—one of the few objects that had been left behind. I can still picture the old bedsprings he described as if I had seen them myself: russet coils bent and broken, snarled like an old barbed wire fence. As we retreated, I watched the cottage until it was swallowed by the trees. I would never quite be the same again. I was and still am captivated by the abandoned, crumbling plaster and peeling paint of the country ruin.

In the years since, I have found solitude in these empty places where no one wants to go. In these forgotten walls, remains a gentle peace borne by ruin. There is no white noise hum of a refrigerator, or air conditioner, leaving a silence that is so intense my ears ring with its absence. In the clarity that follows, objects once lost in the dull colour of weather begin to emerge. And with my attention lightly focused, I am open to receive the secrets that the house releases only to me. I sit quietly and take in each smell, each creak in old boards, each flash of teal, yellow or orange hiding amongst the faded decorations, until the wind-whipped shreds of wallpaper come into tune. Perhaps

you must cherish loneliness to hear the music, or know of abandonment a little. A bird flies in through the broken window and settles on a warped sill painted by the sun and, for a moment, the beauty is so overwhelming, it is grief and hope bound together.

Some of those early houses were built one board at a time, as each piece of wood was brought home by workers after a long day of working at the lumber mill. Nails were made one at a time by blacksmiths, giving them their distinctive square heads. The generation that built these old structures is gone. So are most of their grandchildren. For one reason or another the old house is left behind and the family fades away. Houses are left, some empty, some full of memories — clues to the fates of those who created them. It is the ephemeral evidence of what was once imagined.

This book was inspired by over three years of passionate exploration and blogging about the landscapes and historical places of Muskoka for the "Echoes" series of paintings. The stories that follow are drawn, mainly, from my interviews with the families that lived in these buildings, trips and research where possible, as well as the art itself. I have taken some creative liberties in the telling of stories based on real people and real events. History doesn't often record the thoughts and feelings of everyday folk. Some events, even my own experiences, are subject only to the elegant fluidity of memory.

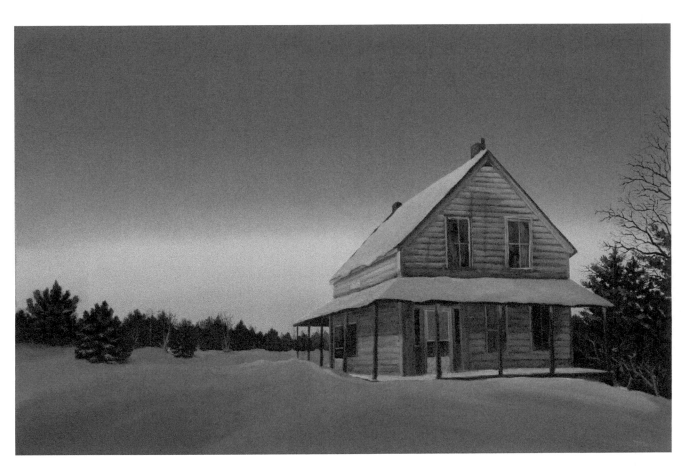

Twilight, 2008
acrylic on canvas
24"x36"
Private Collection

Twilight in Uffington

The near-ghost town of Uffington straddles the crossing of two colonization roads. It is an unusually flat plain with very little of the rock so typical of the region. One corner is empty and last season's grass pushes against a few straggling boulders abandoned there long ago by farmers clearing the land. The bush is reclaiming the dormant fields of all but Bruce Johnson's farm, where horses keep the scrub lining the fences at bay. The hotels of the history books are long gone and the schoolhouse bell no longer rings.

Small communities make wonderful networks. If you know anybody at all, you can connect with just about everybody else. Once I started to ask questions, it didn't take long before I was pointed in the right direction. When research and documentation backed up the folklore, I began to realize there was a whole other side to cottage country lurking down the side roads behind the lakes, pleasure boats and urbanite escapes.

In 2009, a renovation was underway on the last remaining church in town. The Oswin family had been peeling back the layers, rediscovering gothic windows and tin ceilings. The "Twilight" house was the original manse for this church. Nearly a year and a half after first discovering the little building

in Uffington, I was privileged to meet Tom Iddison, the son-in-law of the Flegers, the last family to occupy the old manse. I was immediately struck by his calm and generous nature. We spoke a couple of times on the phone and in May of 2009, Mr. Iddison offered to guide me through this beautiful, old family home and to share tales of his time on the farm. The house had sunk below the concrete porch and the slab had to be broken by Tom and his son Curtis to make entry possible. The first floor was pretty much rotted out. Like many farmhouses of its era, it was built on the ground without a foundation. The carpet hung like a hammock and managed to support our weight in all but a few places. The teal paint on the walls was still in good condition. Measuring cups and a key holder still clung to their hooks beside the kitchen door. The stove was long gone and the stovepipe hole was stuffed with rags.

The house was chilly in spite of the warm spring day. For months I had fantasized about exploring the inside of this mysterious place of greying boards and rippled, ancient glass.

The sober dark wood interior was suited to its original purpose. It was the Reverend Grover Livingstone, once a patient of the first Canadian tubercu-

losis sanitorium in Gravenhurst, who sold it away from the Church a short time after it was built. In 1940, Earl and Dorothy Fleger purchased the old manse several years later from the Johnson family, along with forty acres of land. A fire had destroyed the Flegers' farmhouse further up Uffington Road in the 1930s.

In the years since the visit, I have repeatedly tried to flesh out the details of the story I was told about the fire that drove the Flegers from their first home. I wasn't able to find anyone who knew exactly what had happened. Late in the Depression, Earl Fleger may have been stockpiling gasoline at his house off the Uffington Road. If this was indeed the case, a fire would have been almost impossible to extinguish.

There was likely little he could do but let the gasoline burn itself out. I can imagine the fire burning long and bright, turning the house to embers the colour of madder, and blackened remains might have smoldered for days.

When a community well and electricity came to Uffington, the manse was connected. Hot water still came from a reservoir on the side of the wood stove in the kitchen but filling it no longer required a long walk to the farm's well. However, Tom explained that one year an oil spill contaminated the community well and forced Earl to reopen the original farm well. Tom helped Earl bury a pipe that would bring water

right to Dorothy's kitchen. And he installed a tap. Dorothy quietly enjoyed these little conveniences.

I was talking to a friend about my visit to the old house and she shared with me an amusing story she had been told about one cold January evening at the Flegers'. The lights burned late and the house was filled with music and laughter deep into the night. Leaving the men to entertain themselves, Dorothy retired to bed. Moonlight illuminated the stairs through the tiny sidelight and the heat from the stove emanated weakly from the stovepipes on the second floor. The windows were frosted over, diffusing the light and making the bare bulb in the ceiling unnecessary. Dorothy heard the door slam behind one of the men. Intoxicated, he stumbled into the night in search of the outhouse.

The following morning was quiet but for a few snores in the front parlour. Dorothy slipped out the back door intending to head to the outhouse. She tried to slip on her boots on the porch, except one was full and frozen solid. Her guest obviously didn't make it to the outhouse.

The front window furthest from the stairs was Dorothy's room. At the time of my visit, the base of the window was still packed with rags to block out the draft. When Tom lifted them, we discovered a large gap.

Dorothy lived there into her nineties

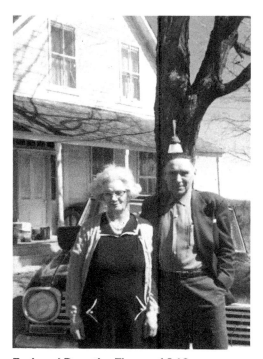

Earl and Dorothy Fleger, 1960s ca.
photo courtesy of
Tom and Curtis Iddison

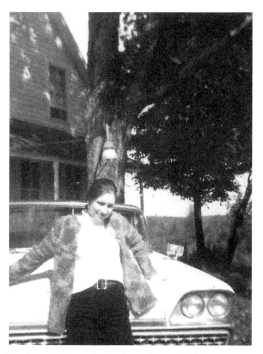

Earl and Dorothy's daughter, 1960s ca.
photo courtesy of Curtis Iddison

without any modern conveniences besides basic electricity. When Earl was too ill, she carried the wood too.

Wandering through the house, I noticed many personal objects; shoes, coats, sweaters and linens left behind. Sitting near the top of an old shipping trunk were several photographs of a wedding that looked like it had taken place in the sixties, likely of one of the Flegers' daughters. The reception was in the local Orange Hall, which still stands today and is close to dereliction. Dorothy's granddaughter Crystal's favourite room was darkly paneled and glowed warm sienna in the morning sun. The room contained only a wardrobe and a single chair next to the window sitting just out of the band of

sunlight. An old vinyl coat was tossed carelessly over it. A pair of Dorothy's shoes held the door ajar and appeared to have been abandoned only seconds before. There were moments when I felt I was intruding on something intimate. I closed my eyes; the smell of stale air and mold seeped into my consciousness and the illusion faded away.

A small bear sculpture with a thin strip of tarnished brass displaying the engraving "Agawa Canyon" sat on the little sill on the inside of the sidelight at the top of the stairs. Back in the days before electric lighting, this little window lit the dark stairwell.

Grabbing a milk bottle from the kitchen sink on the way out to the shat-

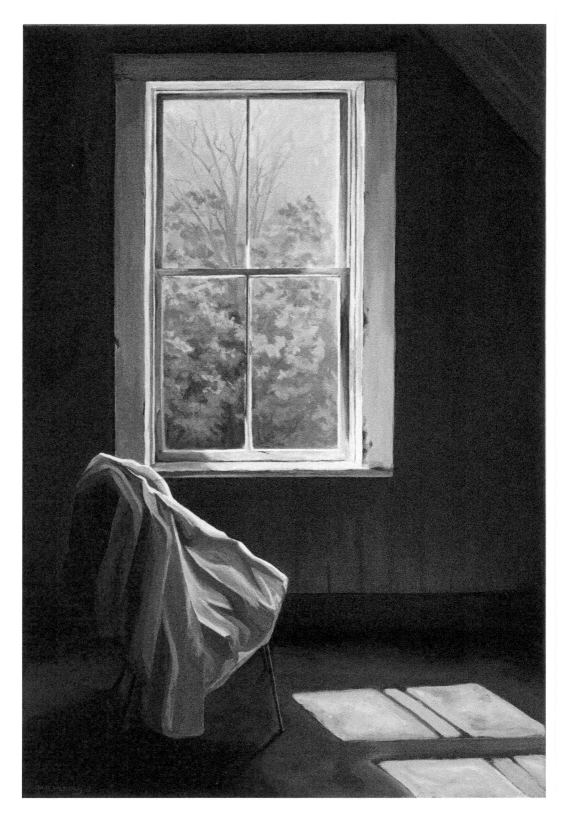

Crystal's Room, 2010
acrylic on canvas
24"x16"
Private Collection

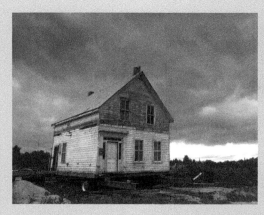

Moving the house to a new foundation, 2010

Measuring Cups, Fleger kitchen, 2009

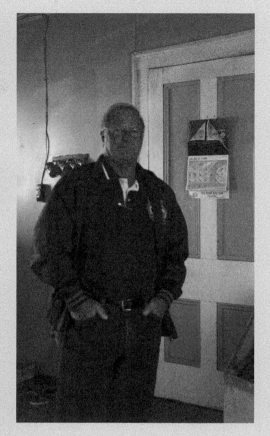

Tom Iddison, 2009

tered porch, Tom offered it to me and smiled. As we lingered together on the porch, I turned the old bottle in my hands. Squared off and with manufacturer marks on its base, it was stained on the bottom and slightly pitted from wear. Tom shared a couple of stories involving milk, machines and mothers.

~~~~~~~

There was a new machine that was supposed to make separating milk from the cream quick and easy. The clerk at the general store in Bracebridge convinced Earl of its efficiency by giving him a demonstration. A process that took hours was done in minutes! Earl paid the clerk and brought the machine home to Dorothy. Generally, they had left the milk in the bucket to separate on its own over hours. Sure enough, this separating machine was fast and the job got done. Earl was thrilled. Dorothy filled the bottles and took them to the kitchen and left Earl to clean the machine. Every moving part needed to be removed each time the machine was used. By the time Earl got the contraption cleaned, he was in foul mood. He returned to the kitchen covered in sweat and complained to Dorothy and Tom that it didn't save him any time at all.

~~~~~~~

11

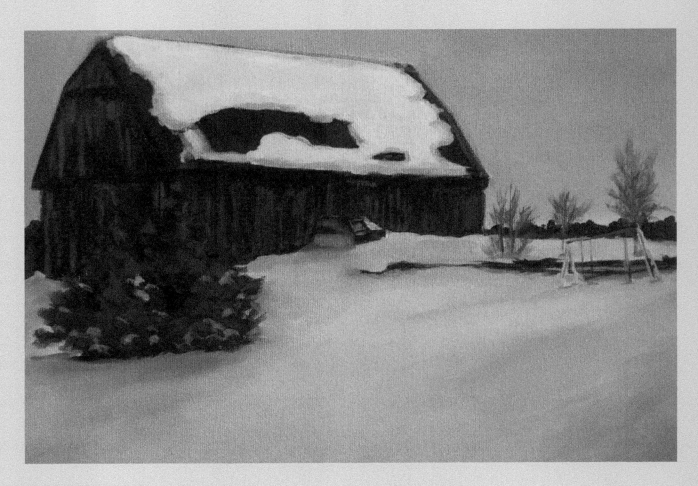

The Fleger Barn, 2017
acrylic on canvas
12"x16"

Agawa Bear, Fleger House, 2009

Dorothy's Shoes, 2009

One spring, Earl urgently called Tom to the barn. One of the cows was about to calf. Earl had broken his wrist while working as a telephone lineman, which meant that he couldn't help the cow and Tom was going to have to do it. Tom had never calved in his life. The cow moaned and as her labour progressed, the time was coming when Tom would have to reach in. Stunned like a deer in headlights, Tom could barely process Earl's rapid-fire instructions:

"Cut the sack when you see it, and pull the calf in rhythm with the cow's contractions until the head and shoulders are out and then just pull! Then show her the calf and get out of there!"

To Tom's great relief, everything went as it was supposed to. Except that he didn't get out of the stall after showing the cow her calf. That was the one instruction he missed. The cow closed in fast and pinned him to the sidewall. Earl told him to push her out of the way, but she wouldn't budge. Earl started to chuckle while Tom gasped for breath.

One more shove and she moved.

~ ~ ~ ~ ~ ~ ~

By the 1990s Earl had become too ill to do the farm work. Dorothy began to carry the wood when her husband could no longer make the trip to the

porch. Tom chopped and stacked it when she could no longer do it for herself. To make things easier for her, the room at the top of the stairs to the left was converted to a "WC" (water closet). A family down the road on the lake had put in a real toilet and offered Tom and Dorothy their "envirotoilet." As long as it had a base of moss and heat, everything worked. It needed no water, just electricity. Dorothy kept a small table with a jug and basin beneath the window, handmade and roughly signed by her daughter.

In July 2009, only a few months after we met, Tom Iddison passed away suddenly. I had the pleasure of meeting his son Curtis after the gallery opening. He is doing his best to preserve his family history. Only months before, the plan had been to tear the house down. Instead, it was sold to Judy Veitch. Judy has deep roots in Muskoka and has renovated the house. It celebrated its 111th birthday on a real foundation in 2011.

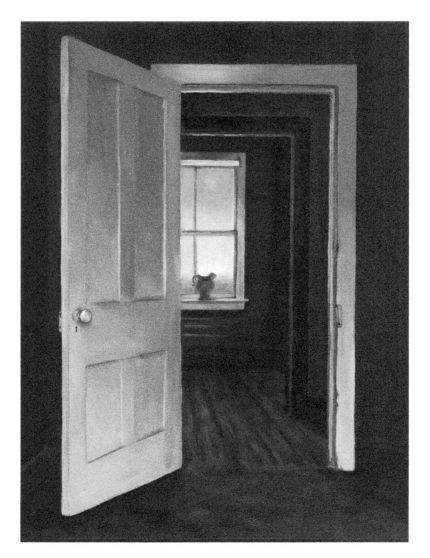

Across the Hall, 2010
acrylic on canvas
16"x12"

Mrs. Fleger's Bedroom Door, 2009
(opposite)
acrylic on canvas
10"x8"
Private collection

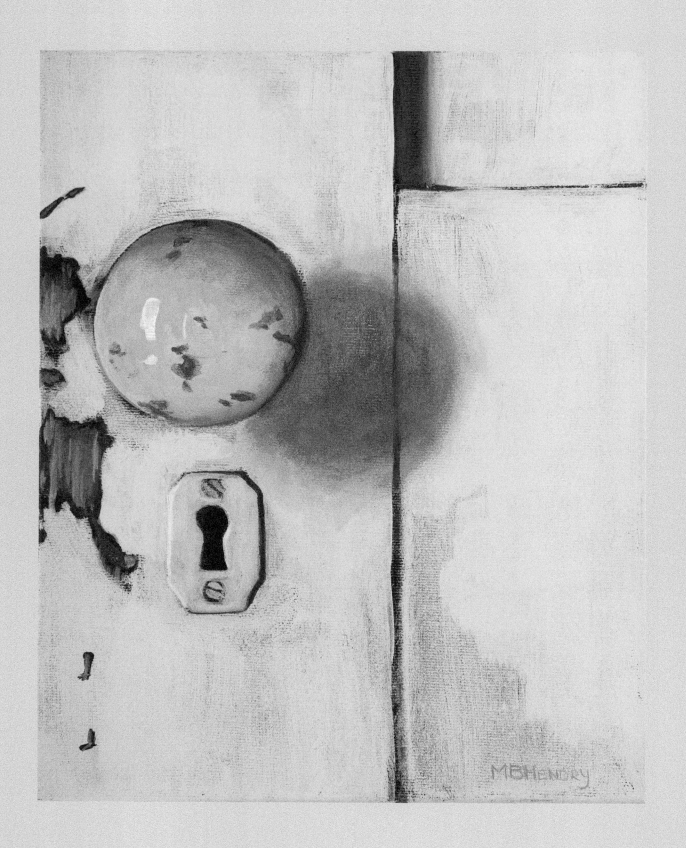

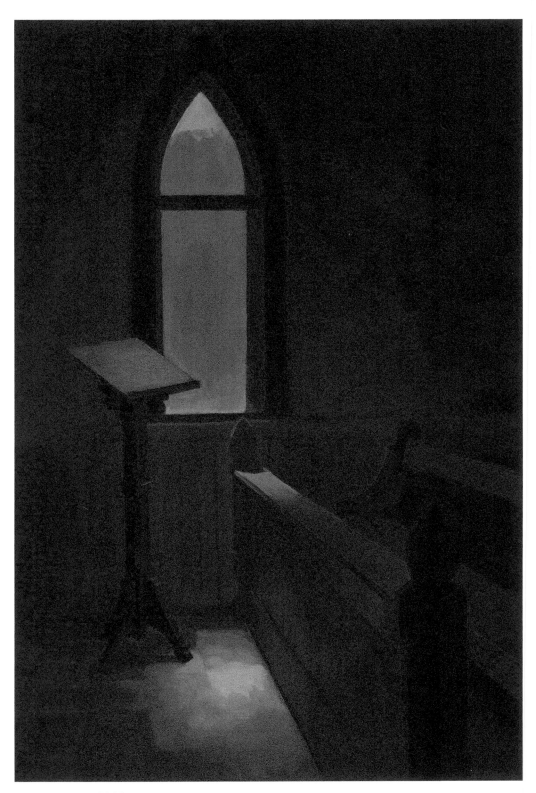

Evanescence, 2009
24"x16"
acrylic on canvas
Artist's Collection

Evanescence

The bush in summer is like a magician's cloak, hiding the architecture of a community's dreams in plain sight. When the people have gone, the sun revises the space, changing the light with each season and shifting the dancing shadows with its singular gaze.

After doing a photo shoot at the Fleger House for a local magazine, my friend Bev McMullen, the photographer, and I decided to explore the remains of Uffington. We went in search of the 120-year-old wooden St. Paul's Anglican Church, which sat tucked in a hemlock grove on the edge of a small hill. We wandered around the outside until we noticed that the lock on the door was broken. A kindred spirit, Bev is an adventurer and a lover of early Canadian architecture. Her passion for Muskoka fills volumes in the local libraries and around the country. Bev immediately went to work taking photographs and I wandered around, taking in the details of this beautifully preserved building. We chatted and worked, but I knew I needed to return with my camera when no one else was there. I needed to tune in to the building, its natural sounds, without distraction.

Alone, my footsteps cracked and echoed on the wooden floor of the abandoned church. Then faded away. The sounds served only to intensify a silence so complete that the sunbeams coming in the stained glass windows seemed to sing hymns of light, the dust in the air dancing to their music. I closed my eyes and listened. Any anxiety I had felt on entering this place alone dissipated immediately. As an imaginative child, I kept a secret place where I would go when the outside world was too much to bear. This church, like the wood fort in the forest of my childhood home, became that private place. But the pursuit of forgotten dreams is a journey replete with loss, and as the child grows the walls of the fortress weaken and fall.

The church was only weeks from demolition.

I had only a very short time in the old church. I planned, drew and painted "Evanescence" fairly quickly. Each stroke pulled at my heart and tried to fill the emptiness of imminent loss. The building was being torn down during the process of the painting. Frankly, I was so emotionally drained from the work that I had to struggle to find again that place of refuge within myself. The painting "Evanescence" represents my memory of St. Paul's. In reality, only

a shallow depression remains where the church once stood. Recovered boards from the exterior now frame the painting.

Uffington had three churches at its peak – a Presbyterian, a Methodist, and the oldest, St. Paul's Anglican. The original log church was built in 1870 and it was replaced by the structure in the painting in 1889. In those early days, the church was supported by a large congregation.

I met Bruce Johnson a couple of years after "Evanescence" was complete. At the time of my visit, Bruce was in his seventies. He had been an altar boy at St. Paul's in the 1950s. At the time, preachers visited each community church in a circuit, riding from one to the next every week. The Johnson family, who were horse breakers originally from Lewisham, kept a farm at the Uffington crossroads which became the stop for the Anglican minister and his horse (and later bicycle!), who came in every Saturday from the Bracebridge Mission House to conduct services for the communities of Uffington, Allen's Corners, Barkway, Purbrook and Housey's Rapids. The minister would spend the night at the Johnson farm and Bruce would clear the snow and stoke the fire in

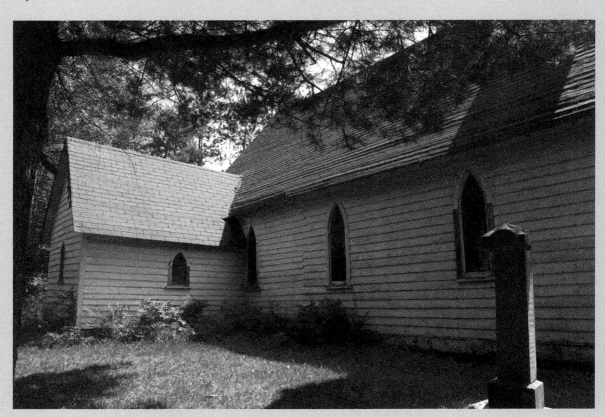

St. James Anglican Church, 2009
(now demolished)

18

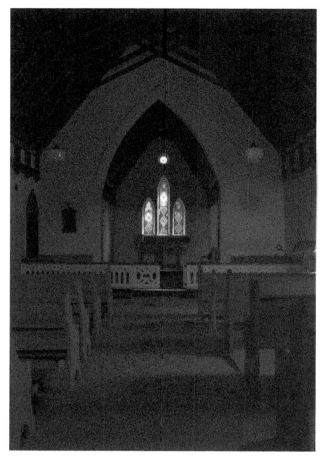

Interior, St. James Anglican Church, 2009

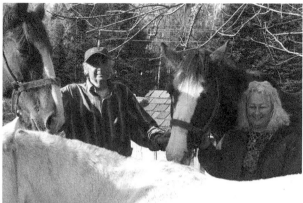

Bruce Johnson and Judy Veitch 2010

the woodstove for Sunday's congregation. Bruce still lives in the family home, which is constantly filled with grandchildren even as the community of which it was a part seems to dissolve around him.

The last regular services were held at St. Paul's in 2002 and with a congregation of only five remaining, it closed in 2005. In late 2008, the decision was made to deconsecrate the church and tear it down. The deconsecration was held on October 23rd and the baptismal basin, altar and pews were removed. For ceremonial and ritual reasons, the altar must be burned. If a new home cannot be found for the baptismal basin, it must be buried. In early 2009, on my last visit, the bell was still there, although the beautiful large stained glass windows in the chancel had been removed. The property was to be used as further cemetery space for the Town of Bracebridge.

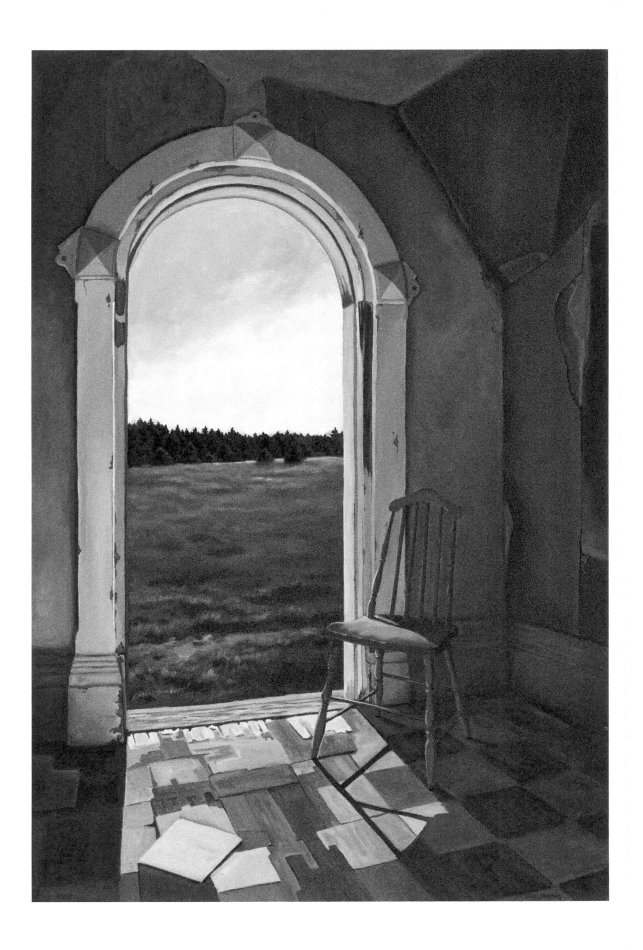

Livingstone's House of Gold

A long bend in the old road between Bracebridge and Gravenhurst sweeps widely around an empty field and runs parallel to railway tracks that still vibrate with passing northern trains. But even if you have stopped to watch the train go by, you have probably missed the ruin of the house Mr. Livingstone built. For years I drove by this old house, wondering fleetingly about it for the few seconds that it was in my sight; until one day the wondering became too powerful to resist.

My first visit was on a cool spring day in 2009. A vanishing rainstorm had left a brisk, penetrating breeze in its wake. The brick house sat blind with its windows shattered or entirely absent, allowing the wind to wander through its rooms unrestrained. A gust moved a loose door, tapping and knocking on its broken jamb. The walls whispered and wailed as the air pushed through the lathe left exposed like an untended wound. Rough shards of peeling paint broke off in my hands and when the wind subsided, the house breathed its musty breath over me.

I walked cautiously onto the floor inside the empty doorway, testing with each step the solidity of the boards beneath my feet. Fragments of the kitchen cabinets and doors were strewn through the entryway and it became evident that the house had been stripped clean. Clumps of plaster lay across the hardwood floors.

In moments of stillness, the house seemed to be awaiting the return of its owners. I found myself convinced that there was some little secret thing – a book or a box – hidden in this house that might have a story in it. It was easy to imagine the life of a young woman living there in the early 1900s. I scoured the crevices and peered behind the baseboards in search of something left by her. But the house held its secrets close, revealing only small things that disappeared like mist before I could grasp them.

Sun, dancing off the edges of detailed mouldings of the bay window, lit the parlour in the southeastern part of the first floor for most of the day and cast the room in a warm glow. The glass was long gone, but the floors were tight and pristine. In spite of the damage, the room felt welcoming and ready for company.

Room with a View, 2011
(opposite)
acrylic on canvas
36x24
Private Collection

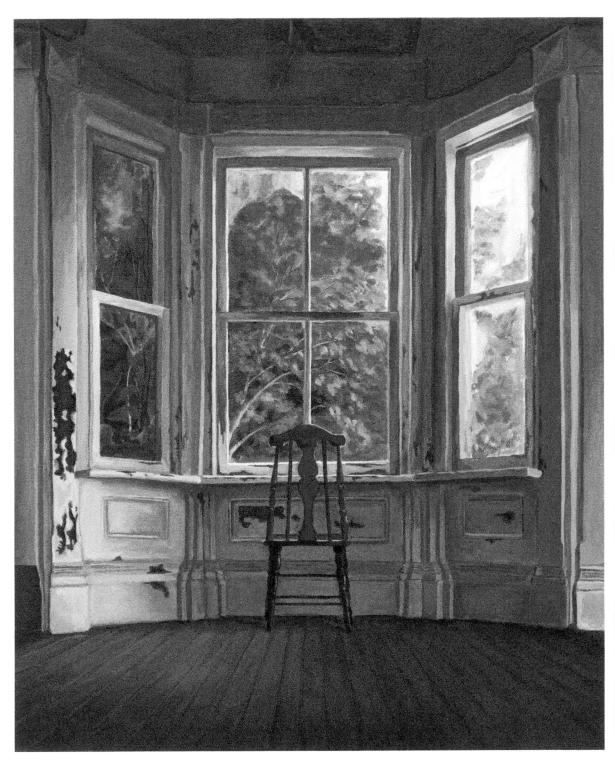

Waiting, 2010
acrylic on canvas
20"x16"
Private Collection

A narrow stairway that was missing its railing curved up to the second floor and it took me a few minutes to build the courage to climb it. The bedroom doors had been stripped of their hardware and each had at least three layers of paint. The last layer was a bright yellow. Moisture had seeped through the cracks and pushed its way back out during the frosts of winter, causing the paint to chip off the mouldings. Wallpaper was peeling to reveal gold, peach and grey. The arched door to the second floor porch was missing and the slightly ragged opening revealed a view of wildflower fields. Following me up the stairs, persistent, the wind continued its melancholy song.

Longing and loneliness hung in the air inside the walls of this beautiful house. I was standing in the parlour when a rustling of the leaves broke the silence. I heard male voices engaged in boisterous and friendly conversation. It sounded as if they were approaching the building. I went to the front hall expecting to meet some fellow explorers, but when I leaned out the doorway, the voices ceased and no one was in sight. My skin began to prickle and I wondered why I had really been drawn here and whether there was a story I needed to discover.

For weeks after that initial visit, I could not shake the feeling that something important lingered in the old house – that a story needed to be told. I couldn't get the house out of my mind and I began to paint "Yellow Door." I poured over resources in the library and at the land registry to solve the mystery. The first owner listed, Neil Livingstone, popped up here and there in connection with public buildings, but there was, initially, little to indicate who he was.

While many farmhouses in Muskoka during the nineteenth and early twentieth centuries were very plain and practical, this house showed the artistry of an experienced and talented carpenter. Farming was often an impossible business due to the rocky terrain, so few would have had the wealth to build a brick farmhouse with so much elegant carpentry. Who was this man?

Following the records, I discovered that the Stephens family, Richard and Belle, had purchased the farm in 1906 after Livingstone's death. I found a link between the family and a contemporary local historian, Robert J. Boyer. He had been a friend of Richard's son, Lloyd Stephens. I decided to see if any of Richard and Belle's children were still alive. A chance conversation with an amateur historian, Ken Veitch, led me to Elva (Stephens) Bowes. Ninety-year-old Elva was Richard Stephens's youngest daughter.

Elva was a very charming and independent lady living on the edge of the original farm property. She had a tiny frame that was in no way fragile. Her

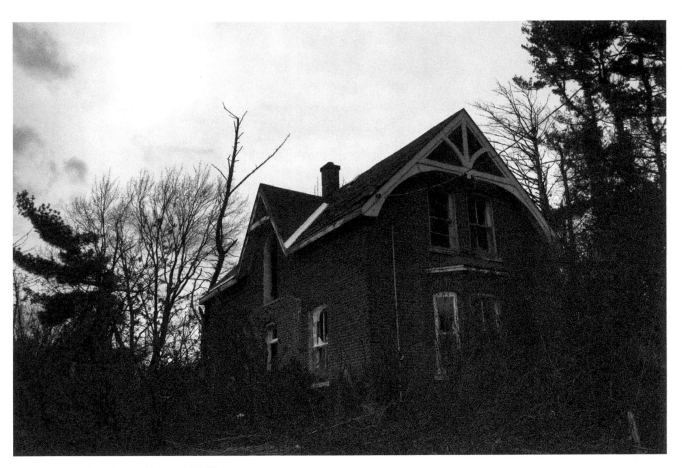

Livingstone Stephens House, 2009
digital photograph
M.Hendry

eyes sparkled in spite of the late autumn darkness and she smiled a big smile that took over her tiny face. She welcomed me inside on that late November afternoon, offered me a seat and asked if I would like a cigarette. I thanked her, but declined. Elva told me her hearing aid was acting up and I would have to write down some initial questions. After I passed her my notebook, she paused, lit her cigarette and told me the story of Neil Livingstone and the farm that had become so beloved by her family.

~ ~ ~ ~ ~ ~

Several feet down a dark muddy hole, Neil Livingstone tried not to think about the numbing cold seeping into the bones of his ungloved hands. His gloves had worn too thin to be bothered with and jobs were too few at this time of year to replace them. The black dirt clung to his fingers with the wetness of moss releasing the ice of winter. He was soaked with sweat beneath his coat. Digging a well was rough enough going when it was rocks and soil, but the ground had turned gravely, and the pebbles slowed his progress. He climbed out of the hole and pulled out his flask. He drew a long swig and the whiskey warmed his throat. This backbreaking work was getting harder. He was only in his early twenties when he hopped the ship from Scotland. He was a trained carpenter and had figured he could make his fortune here.

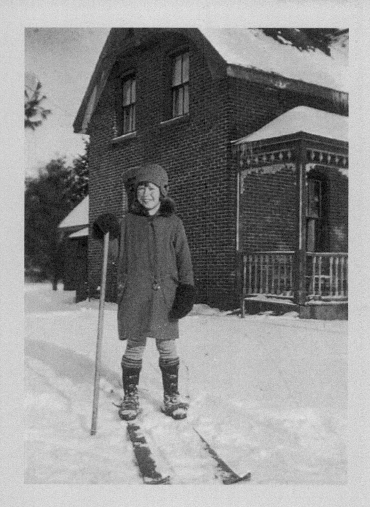

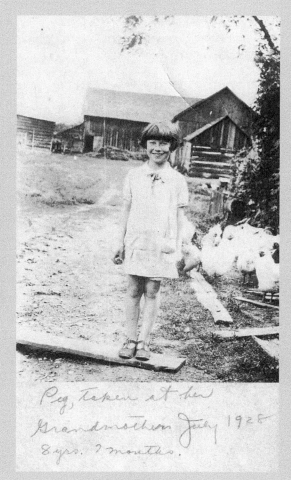

Peg, taken at her
Grandmother's July 1928
8 yrs. 7 months.

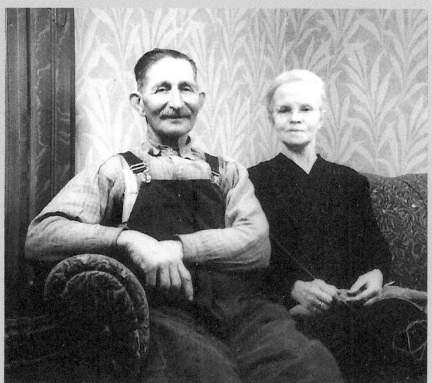

Elva on skis at the house 1930
(top left)

Elva in front of the barn, 1928
(top right)

Belle's handwriting on back of Elva in front of the barn
(above)

Richard & Belle Stephens, 1940s ca.
(left)

Photographs courtesy of Jane Morgan

Yellow Door, 2009
acrylic on canvas
18"x14"
Private Collection

Livingstone walked around the debris pile looking for a dry place to sit when something caught his eye. He pushed away the soil and pebbles to expose a yellow stone. It was a nugget of pure gold. His heart leapt. And then he went to the Albion Hotel and bought the boys a round.

With a little money now behind him, Livingstone began to place bids to build town buildings. He won the Bracebridge Jail with the lowest bid. Livingstone's crewmembers, many of whom had questionable histories, often spent short sojourns in the newly built jail following drunken brawls or attempted thefts, and Livingstone would collect them there when the magistrate saw fit to release them. But then, the jail was also a place a man could reinvent himself. He also built the firehouse tower and the second and third floors of the Dominion Hotel. In exchange, he had a place to live and a big credit with the Hotel's barkeep.

After the miraculous discovery of gold in the well, Livingstone suddenly found himself more marriageable. Being a long-time bachelor, he had never expected to marry. A local man put forward his spinster daughter. Livingstone accepted. He did not lie to himself about his reputation. His living arrangements and the company he kept began, for the first time, to concern him.

In 1891, Livingstone broke ground for the best farmhouse in Muskoka. He started with one of those mail order plans and got to work. He could afford all the building materials, and brick too. That ought to make his bride happy. The work was slow and exhausting and the bugs on damp days were merciless, but once the summer heat burned them back into the bush, he began to do the interior carpentry. The floors in his house would not be plank, but finished and tight to last 500 years. The staircase would be curved because all the fanciest homes of the wealthy had curved staircases, and the upstairs porch would extend beyond an arched doorway with two glass-paneled doors to light the hallway and stairwell. The house would have a big kitchen. Livingstone imagined home-cooked meals and preserves in the basement cold cellar. His calloused hands always damp with sweat, he would return to town after dark, dirty and exhausted. Every night he dropped himself next to the bar. His gnarled hands gripped the dirty glass and he could see his reflection in the mirror. His face was red with both sun and drink. He stayed until even the rowdiest patrons stopped breaking glasses, sometimes assisting in the removal of a member of his crew to the muddy street. At the end of each night he would stumble up the stairs to his room.

Livingstone's bride was having doubts. To be trapped in the bush with a man more in love with his drink than his wife is a mistake many before her had

His gnarled hands gripped the dirty glass and he could see his reflection in the mirror on the bar.

Window Seat, 2009
acrylic on canvas
18"x14"
Private Collection

made. The abuse of liquor was a serious problem in these lumber towns. Men outnumbered women and hotels and saloons outnumbered churches. There were shacks by the railroad no proper woman would ever want to be seen near. It seemed that the grunts barely muffled by thin plank walls did not hide their intent and were bold in the face of a society of laws. She decided she could not do it.

She stood in front of the new brick house and listened to the laughter of men preparing their celebration. The beautiful rust brick home had been finished late in the summer. The south-facing porch was painted the colour of the dark stained wood that lined the stairs and doorways of its luxurious interior. Wallpaper covered the walls up to the high ceiling in the parlour. The plaster was smooth along the curves of the ceiling all the way to the second floor. The late summer sun added warmth to each room, empty but for a tiny wood stove already burning to show that no room would ever be cold. She left and never returned.

Crushed, neither did Livingstone.

A decade after Livingstone abandoned his house it was turned over to Peter Milne, the operator of the Dominion Hotel. Livingstone had lived out his final days in the Hotel's upper rooms. The rooms that he himself had built. Bed, board and burial. Paid for in full.

~~~~~~~

Elva paused. Her cigarette burned low. The late November light streamed weakly into her living room. We were less than a mile from the farmhouse. Milne had divested himself quickly of the farm. He could see which way the winds were blowing and moved his family to Alberta. Richard Stephens took over in 1906. Elva had always wondered how her father had known Milne, a barkeep.

Elva loved winter at the farm. She could play and ski and run about without much trouble. Her mother, Belle, was busy tending to things while her father was working with the logging crew in Matthiasville. Her mother always said that a farm was a big responsibility! The farm had two barns, a drive shed, henhouse, ice house, pig pen, and a field for sheep, horses and cows. Elva's sister, Leola, would help her mother in the house and took on jobs like sewing to do her part. Her brothers, Earl, Ross and Lloyd, took care of the animals and were often out in the barn. Elva often lingered nearby and listened to them as they worked. Ross loved to tease her. He was full of life and Elva loved to spend time with him. He always reminded her that he used to be sick a

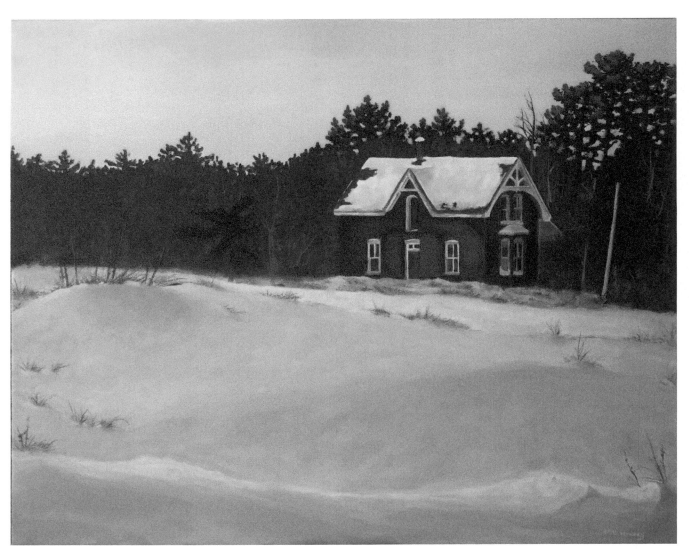

**Remains of the Day, 2014**
acrylic on canvas
24"x30"

lot and that he was only alive thanks to Dr. Frederick Banting and his insulin. Ross died in 1944 due to complications of diabetes.

In summer, Belle tended a vegetable garden behind the house with peas, beans, carrots, potatoes, onions and tomatoes. In her perennial garden, she had irises, phlox, lemon and orange lilies, four o'clocks, wild roses, and purple and white lilacs. Elva shared a second floor room with her sister with a view of both the garden and the road to town. She could see the comings and goings and as she got older, she, too, began to leave the farm for work.

When Elva's grandfather Thomas retired from his own farm, he moved in with her family and was settled into the parlour of their farmhouse. A mirror was rigged up by the bay window so that he could see when visitors came up the long farm lane from his chair. Early on summer mornings, the sun would reflect in the mirror, making a bright spot on Neil Livingstone's tight wood floor. Thomas was ninety

**Stephens House, 1940**
Photo courtesy of Jane Morgan

when he passed in 1936.

Elva would often sit at the top of the curved staircase and listen to her parents' conversations. She heard stories about her mother's Irish family and how they came to Muskoka in the 1860s to escape the Fenian conflicts. Bitterness and grudges followed immigrants fleeing famine on ships riddled with disease and death, poisoning Canadian shores. Elva's grandmother, Henrietta Corrigan, lost her father when he was murdered at a fair by Irish Catholics. Henrietta married Angus Morrison and died when she was only thirty-one, leaving her daughter, Elva's mother Belle, to grow up with a step-family. Elva heard her mother say that Catholics were the same as everyone else and were always welcome at the Stephens's home. She did not want the past to taint her future.

A large pine grew on the northwest side of the porch. The pine is in nearly every photograph of the house. In my visit to the old Stephens farm, I noted that the tree seemed broken, its branches growing in a strange pattern. It turns out that this twisted tree wasn't natural. Richard used to be concerned with the height of the tree and would shoot the top off with his .33 rifle to prevent it from growing too tall.

In 1955, while Elva was in San Francisco, her father came in from the fields looking tired. Belle suggested he take a nap before dinner. He never awoke.

After her father's death the farm was sold, leaving only an acre and the farmhouse for Belle, Elva and her son Don. When Belle died in 1960, the farmhouse was transferred

to a corporation and Elva left the farm for good.

As darkness descended, the windows filled with a deep charcoal and the unusually warm afternoon was overtaken by the pall of snow-heavy clouds. I gave Elva a big hug and said goodbye.

Wading through the census information for 1911, I discovered that shortly after the Stephenses purchased the property, Edward Cronin, the eldest son of a neighbour and only fifteen years of age, lodged with the Stephens family, possibly as farm labour. Elva has no memory of him, so he was likely gone by the time she was born. I wonder, from time to time, if it may have been the echo of Edward's voice and maybe one of Richard's sons coming in from the fields that I heard on that windy spring day?

**Elva (left), 1940s ca.**
Photograph courtesy of Jane Morgan

Elva passed away in the summer of 2011 and is buried with her parents. Belle's phlox still grow in the garden in front of her now empty house and in the gardens of Belle's great-grandchildren.

I have yet to find the resting place of Neil Livingstone.

During my last visit, the whispers and intensity of this house seemed to have quieted and, as if satisfied, the house seemed to return further into nature. In 2012, more than 120 years after the first brick was laid, the bricks were removed and the house torn down, passing into history.

**Belle (right). Note the changes in the veranda over the years. Date Unknown.**
Photograph courtesy of Jane Morgan

**Livingstone Stephens House, 2009**

**The Stephens brother's, 1940s ca.**
Photograph courtesy of Jane Morgan

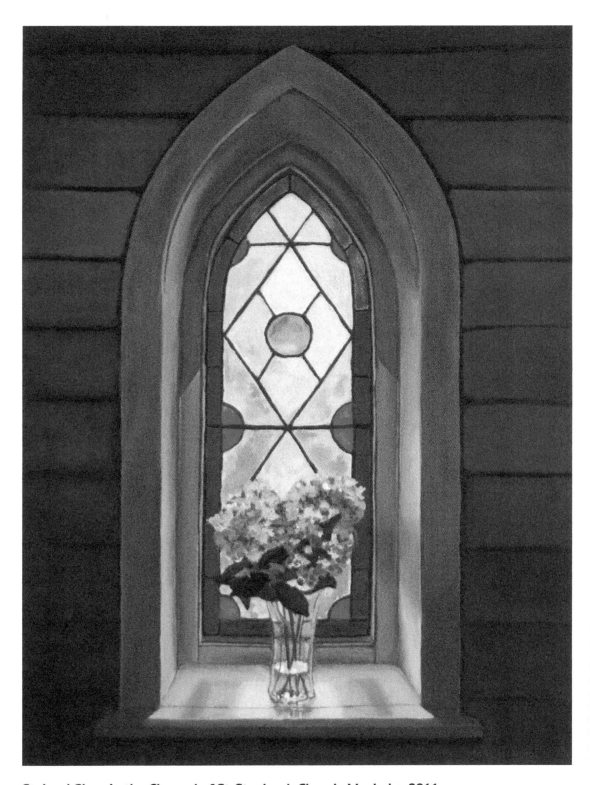

**Stained Glass in the Chancel of St. Stephen's Church, Muskoka, 2011**
acrylic on canvas
16"x12"
Private Collection

# Tiny St. Stephens

Black water runs gently under the bridge at Vankoughnet and the bush is silent and filled with secrets. Cracking cedar shingles and mossy stones collect moments like playing cards being shuffled and dealt even when all of the players are asleep. The church bell rings, too loudly to have been stirred by a gust of wind. Sun breaks through the stained glass windows and colours chase one another across the old wood floor of St. Stephen's Anglican Church.

Fall moves in quickly after Labour Day and shadows lengthen across the manicured churchyard. For years I had heard of the riverside village and its very tiny church. Vankoughnet was a significant logging town and depot at the turn of the twentieth century. It is now a quiet community on the banks of the Black River.

St. Stephen's is one of the smallest churches I have ever seen: around 900 square feet, including the chancel and vestry. Now a chapel, St. Stephen's was originally a 'sister' church to St. Paul's in Uffington. Cool grey siding and a heavy white wooden door lead into a close space filled with simple wooden pews and a dark stained ceiling.

On the day of my first visit, a formal Requiem service was delivered to a capacity crowd. It had been a while since I had attended a church service. It reminded me of Sundays with my grandfather. Every summer, we would go to mass in Mactier and then have breakfast at the Wagonwheel restaurant on the side of the old Highway 69. It was a ritual of my childhood, abandoned.

I mingled with some of the older citizens of the congregation, including Bernice Gillies, granddaughter of the Flaherty House's last resident. Just a short distance from the church, the Flaherty House was once the fancy house in town. Its high end finishes and bay windows stood out in the humble logging town. It hosted guests of distinction and had been home to Bernice's grandmother until she passed away. It has now been empty for around sixty years and is quite derelict.

I struggled with the painting of this

**St.Stephen's Anglican Church, 2010**

church, and it went through a couple of drafts before I settled on the little window. St. Stephen's is still active. Many voices still inhabit the place, making the process of drawing out just one story more difficult. In spite of its considerable age, there were no dusty corners and the paint was fresh. If it has secrets, they are hidden. Through the filtered light of stained glass, history here is still being written.

St. Stephen's recently celebrated 120 years of continuous service. The painting was auctioned to support the fund that maintains this unique building.

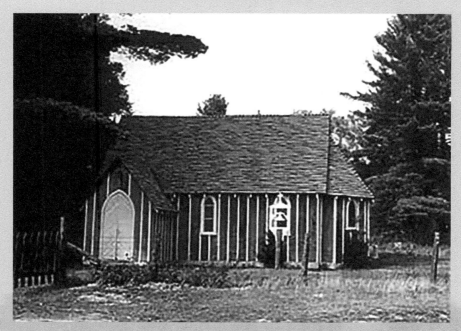

**Historic photograph of St. Stephen's. Date unknown.**

**Flaherty House, 2009**

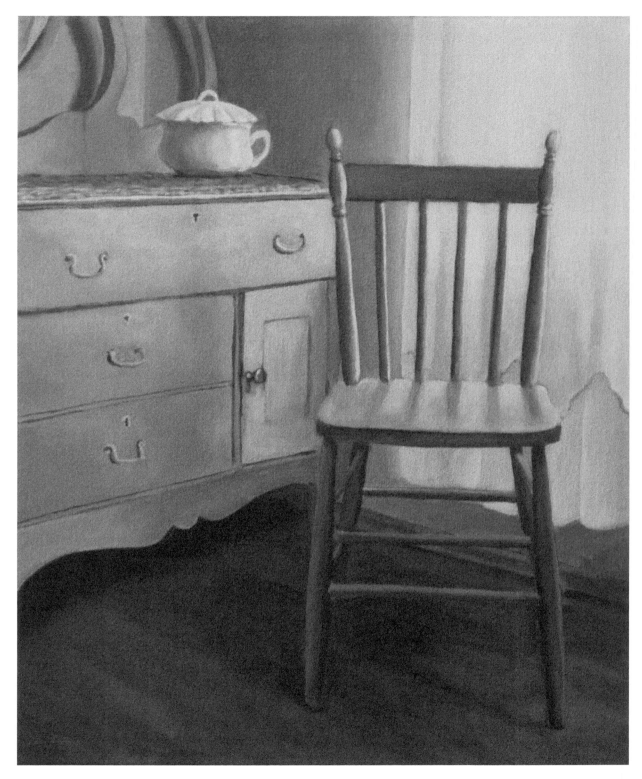

**Lakeside Room, 2012**
acrylic on canvas
12"x10"

# Sparrow Lake Castle

It is a rare experience to have the privilege of visiting a place that seems frozen in time, where the voices of those from another era echo through the halls and warm summer memories linger. But at Sparrow Beach Lodge the whispers of winter seeped through the walls, pushing the songs of summer aside during my late October visit. Beds were made and linens were tucked away as shadows lengthened and light faded.

Originally the Vanomi Hotel, Sparrow Beach Lodge is a privately owned 100-year-old resort that has only recently closed its doors. In its early years, the resort hosted vacationing fishermen, businessmen and their families fleeing the smog of industrial Ohio. Hot summers in the city were oppressive. Pollution made the air thick and black and drove anyone who was able to escape to the lakes of Muskoka. Hotel culture dominated the region long after the lumber-depleted forests had been abandoned. Some stayed for a few weeks, some for the entire summer. Resorts were more often than not a second home for many of their patrons.

The trip began on steamships across the Great Lakes, then onto the crowded platforms of Union Station in Toronto. A train went overland to Severn Bridge and eventually to Port Stanton. After disembarking with a considerable amount of luggage that would appear excessive to even the most indulgent of today's airline travellers, guests boarded another steamship or launch to the hotel's docks. In its last years of operation in the 1980s and 90s, Sparrow Beach Lodge was a comfortable retreat for young musicians.

My discovery of the Lodge was an adventure in itself.

Dozens of rocky farms line the edges of Southwood Road, picturesque barns and rails heading north. I took a late-season excursion to find the recently rescued log Southwood Church, travelling from the southern end at Highway 11. The drive took so long that I began to think I had missed the church. The autumn afternoon temperature dropped low. Muskoka was past the peak of colour, the last of the summer's greens already turned to brown. The still air was heavy with the expectation of snow.

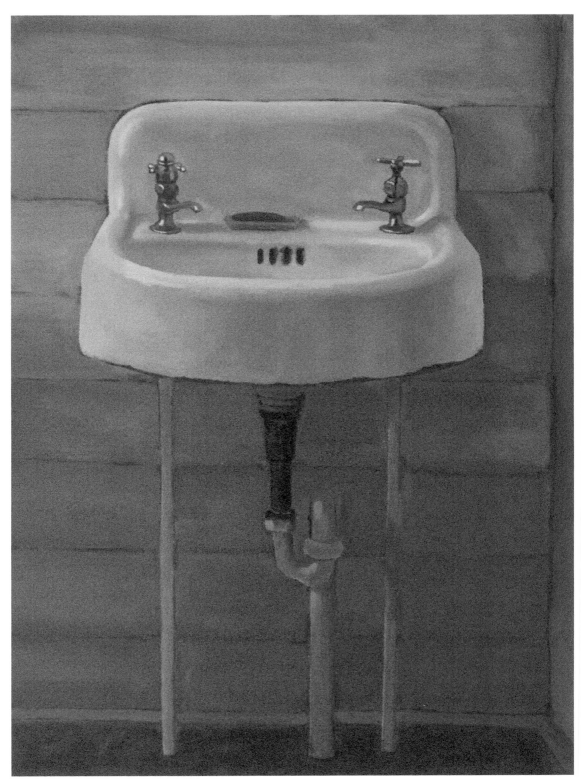

**Time to Wash Up**
acrylic on canvas
16"x12"

**Sparrow Beach Lodge, 2010**

Eventually, I decided that I must have missed it and pulled into a driveway to turn around. As I reversed, I saw a very elderly gentleman sitting in a chair at the other end of the lane. He waved me in. I shut off the engine and met Stanley Socha.

Stanley, ninety-two years old at the time of my visit, invited me to sit with him. He shared his recollections of Sparrow Beach Lodge.

Stanley was a gentle and soft-spoken man, almost aristocratic. A Spitfire pilot in World War II and Polish by birth, he escaped Poland just ahead of Hitler's arrival. A brave young man, he ended up flying above his enemy in the Polish Squadrons of the RAF. After the war, he immigrated to Canada and commuted to work in Cleveland, Ohio from the Lodge during the summer. Stanley spoke of how beautiful the lights leading down to the water were in those days. He and his wife, who passed away recently, had stayed there many times before they decided to purchase the hotel. They owned the Lodge for a few years in the 1970s.

Stanley talked about the old building with its ancient furniture and three storeys of rooms. The top floor was mostly unfinished. Stanley explained that the windows in the stairwell provided more than light. Many of the old wooden hotels succumbed to fire. The Sparrow Beach Lodge still had evidence of the old-style fire escapes; on the third floor a large metal ring was fastened to the wall by the window and the end of a very thick rope remained. Guests escaping a fire in these early resorts would have to drop out the window and lower themselves to the ground. To Stanley, the plunge from the third floor was terrifying. "I didn't like the top floor," he told me, "If there was ever a fire there would be no way out! So I never stayed up there."

*Guests escaping a fire in these early resorts would have to drop out the window*

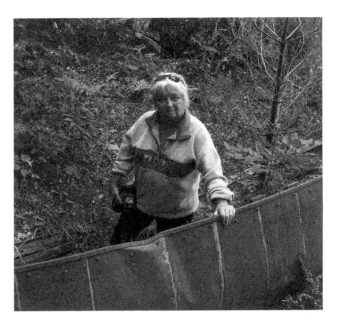

2nd Floor Hallway, Sparrow Beach Lodge, 2010          Bev at the 'Disney' boat 2010

Before I left he gave me a little domed photograph – a souvenir from the Lodge.

Inspired by my visit with Stanley, I changed my destination. I drove down the narrow gravel road and stopped at the Lodge gates. I could just see the large white building through bare trees. The light was fading quickly and the sky seemed to glow behind the old hotel. Perched on the hill, high above the water, it reminded me of an old castle on the edge of a Scottish loch. I knew I must return.

A year later, I got my wish. I asked my friend Bev McMullen to accompany me, and at the Lodge we met Walentina and Taras Rodak. Walentina ran the hotel after purchasing it from Stanley and his wife in the 1970s.

Bev and I could barely contain ourselves, and we wandered around like children in an ancient and life-sized dollhouse. Walentina was a gracious and enthusiastic host. She brought out some of the oldest objects from the Lodge, including a 1950s price list and one of the original chamber pots –

one of the few in existence that had not lost its lid.

Walentina led us on a tour of the hotel, acquainting us with the different sections, floors and rooms. Some of the rooms were used for storage, filled with sinks, laundry and even, in one case, with beautiful, old and slightly tarnished bed frames.

Given permission to wander on our own, I spent most of my time on the top two floors. The second was set up for guests and the third was largely empty. Several rooms on each side of the hall had a bed, dresser, chair and porcelain sink. Toilets and baths were at the end of the hall and opposite each other. Paneled walls painted teal cooled the golden sunlight that poured through the gauzy curtains on the lake side of the building. On a warm summer day the walls would evoke cool water and soft breezes. Where teals and pinks were found in the rooms that faced the southern lake side, yellow paint covered the doors on the landward side to compensate for the lack of direct sun.

The grand, solid wood staircases in this building were

impressive. They barely showed any wear despite 100 years of trailing hands and stolen slides of children that ought to have marked the banisters. The windows flooded the stairwells with natural north light that was warmed by the bare wood-panelled walls. The entire building was made of wood, from the walls to the floors to the ceiling, some painted or stained, some not, the unpainted boards giving the air on the second floor the smell of my grandmother's hope chest.

The stairs ended on the third floor. French doors with delicately frosted glass and brass hardware opened up to a massive hallway that was not fully closed in. Due to the prohibitive cost of insurance, the third floor was never used. It was colder than the lower floors and the walls were mostly unfinished. Old furniture and miscellaneous objects filled the open spaces. It takes remarkably little effort to imagine what guests sixty years ago might have experienced here. It is truly untouched.

Before descending the stairs for the last time, I lingered on the second floor. The late October light had begun to fade and the single bulb illuminating the darkening hallway produced a new geometry of shadows and hinted at the mystery of night in the old Lodge. Alone in a lakeside room, I allowed the cracks and groans of the walls to envelope me, absorbing me in the colossal building's embrace.

I have a special affection for the late autumn world, the cold and quiet of Muskoka when the tourists have left. It was not difficult to imagine this massive building as a stone castle, leaning into the wintry wind under a bank of steel gray clouds.

As Bev and I were leaving the hotel, Walentina told us about an old boat that sits on the other side of the point. Bev learned later that it was once owned by Walt Disney. We went down to the shore and all that remained was the metal hull, rusting with holes where weary rivets had shattered under the weight of snow.

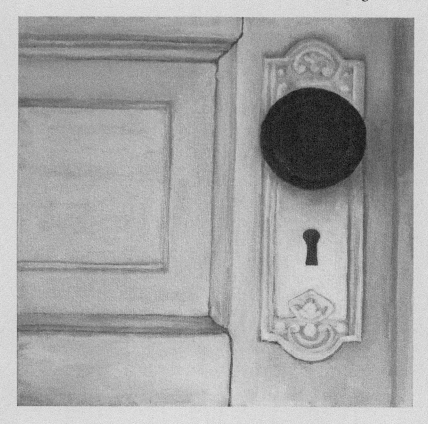

**Sparrow Beach Lodge Door, 2011**
acrylic on canvas
8"x8"

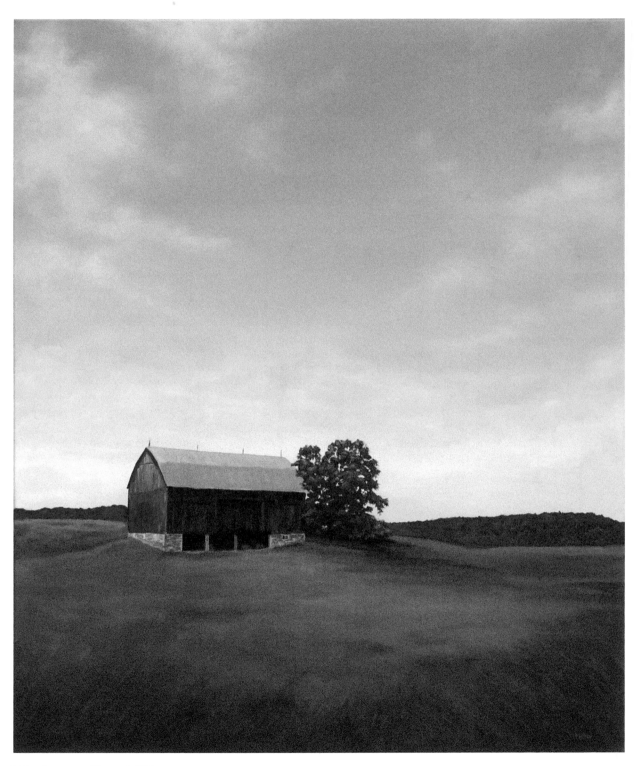

**Windermere Barn, 2009**
acrylic on canvas
30"x24"

# The White House

In summer, the old "White House" is barely visible from the road for dense overgrowth and brambles. After the leaves fall, the house emerges. Seasons of disuse are revealed in rotten floors and the crumbling foundation. Soon, the weight of winter will bring it down. The "White House" has been empty for close to thirty years. The white walls lean, the air inside perfumed with the pungency of bats. Even the wind shies away from its rooms, the doors and windows barred by a tangle of trees and brambles.

It was an unusually warm and sunny November day that I met Ken Veitch and Bill Shea at the "White House", Ken's childhood home in Ufford, Muskoka. The "White House" has two peaks, the result of moving two separate but nearly identical buildings together. This was done early in the house's history, but Ken couldn't tell me exactly when. The western (left) half of the house was where most of the living went on.

Access is no longer possible through the west kitchen; the door was nailed shut long ago, and nature has been complicit in barring entry. We were forced to climb through a window, avoiding a hole in the floor made by resident raccoons. Small objects and broken pieces of wood were strewn across the floor and doors with rusty hardware and cracked paint were stacked against the inside wall. Everything in the kitchen was coated in a thick layer of dust. Ken looked back at the stairway and shared a story:

~~~~~~~

Cold air rushed in past the brown and white door to the kitchen of the "White House" and Ken's uncle closed it quickly behind him. The wind caught the screen door and it slammed shut. The dimly lit room was already full of people huddling on the sofa and taking in the warmth of the large kitchen stove.

Ken's uncle recited Robert Service poems, remembering each line with perfection. A guest suggested that his memory had been improved by his catching a lightning strike through the kitchen water pump. The room filled with chuckles and another voice stated that this was an experience he had had more than once!

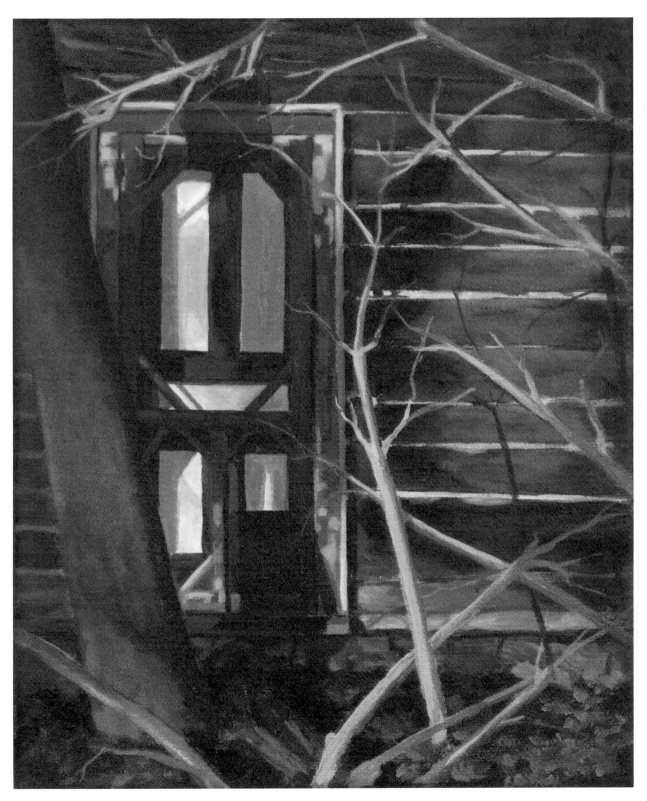

Hidden, 2012
acrylic on canvas
10"x8"

The back room next to the kitchen had once been used as a post office for the community of Ufford. Ken used to hide in the post sacks, but once rural delivery began, the space was converted to a radio room. This evening's guests listened to the crackling broadcast. The radio display gave off an eerie light.

~ ~ ~ ~ ~ ~ ~

The stairway was right in the centre of the house's back wall. It made two turns and opened into a large, dark hallway with a very low railing on the edge of the stairwell. The stairs were so narrow that I am not sure what I expected to find at the end of them. It was almost as if we were in the earthen space within the trunk of a giant tree. Our footsteps echoed off the panelled, papered walls and pine floors. A solitary picture of a vase of flowers decorated the stairwell and when I inspected it closely, I could see the cuts and grooves of an old puzzle. Except for this picture, the second floor was devoid of decoration and without furniture. Only a few weary curtains and blinds remained. It made me wonder why the puzzle picture had been left behind.

On the eastern side of the building remnants of old military cots and maple syrup filters were strewn over the floor, evidence of the farm's activities nearly half a century earlier. This part of the house was merely a shell. Ken wandered near the front door and said, "This room used to have walls," and shared another story.

~ ~ ~ ~ ~ ~ ~

Ken stood on his grandmother's feet. In every direction were the knees and dark clothes of people gathering around a large wooden box. Just two years old, he struggled to peer over the edge of the box. In it laid a woman with her hands crossed. The woman in the box wasn't moving. He looked up at the ashen face of his grandmother. The room was filled with murmurs of tragedy. "Her poor

It was almost as if we were in the earthen space within the trunk of a giant tree.

Kitchen water pump, 2009

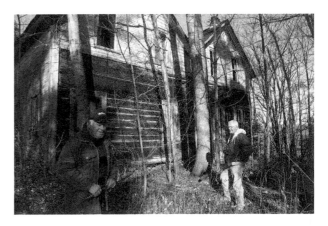

At the White House, 2009

Bill Shea (left) and Ken Veitch at the house, 2009

kidneys couldn't take another one," they were saying. The woman in the box was his mother.

~ ~ ~ ~ ~ ~ ~

Near the back of the house was an overgrown path to the ruins of a barn and where the old pigsty used to stand. We stood in the still November air and, for a moment, past and future merged. We tuned ourselves to the quiet and to the almost imperceptibly slow aging of the buildings beside us. A cat crawled through the logs of the collapsed barn, curious about our presence, and then disappeared.

Pigsty, 2009

Old General Store at Swords, 2008
acrylic on canvas
24"x30"

Crossroads ~ Swords

The gold and purple weeds of a chaotic garden lean toward a stone foundation. Above it, a weary roof spine relaxes from 100 years of long labour. Although not abandoned, the old General Store in Swords has a distinct personality acquired by its logging history and proximity to Parry Sound. Like the classic beverage signs still clinging to the walls of the building, history displays itself here to those who look for it. Built on the edge of the rails the old building still watches over a crossroads once busy with carts and trains, since replaced with ATVs, snowmobiles and automobile traffic.

Swords is one of many abandoned towns near the Nipissing Colonization Road. The road was one of several built to open up the north to settlement before the railways came through, changing the fates of many of the surrounding communities. Originally called Maple Lake Station, Swords was established in the mid-1800s in response to the demand for lumber, but the town really didn't come into its own until the arrival of the Booth Railway in the 1890s. The community was originally a whistle stop on the Booth Railway (Ottawa, Arnprior and Parry Sound Railway) leading to the ghost town of Depot Harbour. Built by the Ludgate Lumber Company in 1894, the General Store supported the expansion of lumbering and homesteading in the area. The post office was added in 1897 and Swords enjoyed a short boom era. As the forests in the area were depleted, the industry continued to move north and the lumber company began to sell its holdings. In 1900, Thomas Swords purchased the store and attached residence. In 1928, gas pumps were added. A road trip here would be dusty and gruelling, making the stop a welcome relief for travellers looking for rest and refreshment. The General Store was the lifeblood of the community and the source of pretty much everything a resident might need: mail, tools, clothing and food. But, as was the case for so many northern communities dependent on the railroad, the town's fortunes began to decline in 1930, when traffic from the lumber industry slowed to a trickle. The station was closed in 1946 and trains stopped altogether in the mid-1950s. Most of the town quickly faded away. The General Store was left with few clients to support it. The town's fate was finally sealed in 1967 when the post office contract was replaced with rural postal routes and the store was forced to close. *

* Details on the history of Swords can be found in Andrew Hind and Maria Da Silva's *Ghost Towns of Muskoka* (Natural Heritage, 2008)

In 2008, a couple of ladies saw the Swords painting at my solo exhibition at the Auburn Gallery in Gravenhurst and they shared a little-discussed fact about the history of the Swords General Store. Back a little ways in the bush is the ruin of an old shack. Hidden by the dense bush, the little shack was rumoured to be used as a brothel by the lumberjacks. I found out later that the ladies telling the story were nieces of Jack Swords, the last member of the Swords family to own the building.

In the 1930s the building was sold out of the hands of the Swords family and it has been the beloved home of three generations of Lawsons.

My tour guide of the old Swords General Store and the attached house was Donna Haslehurst. She is the granddaughter of the first Lawson to occupy the building. It is still tended by the family but is beginning to show its age. Every winter, the basement floods and turns to ice. The roof spine of the store is coming away from the building as the foundation sinks and the weight of snow takes its toll.

I arrived in Swords to meet Donna in the mid-afternoon one November day, long after the tourists of North Muskoka had left for the season. It was crisp and sunny, without a cloud in the sky. As Donna put the key in the padlock on the unpainted, tea-coloured door, excitement tingled through my skin. I had visited this building on two previous occasions, marvelling at its original condition. I used to imagine what it might be like inside, never dreaming that I would get the chance to see it.

Immediately inside the back door, the space opened up to a stairwell and to the left, a massive kitchen that still is inhabited by the spirits of Donna's grandparents, Harriet Haslehurst and Wilson Lawson. Here, Donna shared her first story.

~~~~~~~

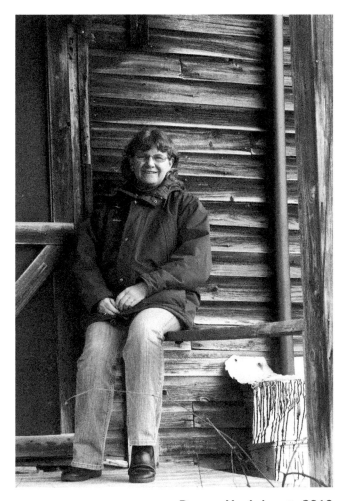

**Donna Haslehurst, 2010**

Wilson loved his chair by the stone fireplace. He would sit between the hearth and the window for hours at a time taking in the heat of the iron stove. On the coldest days, the huge stairwell to the second floor was closed off with a giant trap door to keep the heat in the kitchen and the room occupied during the day.

One Sunday morning Donna decided she was not going to church with her grandmother. Although she was prepared to dig in her heels, to her surprise, Harriet agreed immediately. Donna quietly celebrated her victory and her mind began to fill with possible adventures to occupy her newly acquired free time. But that free time was short

lived. Standing by the back porch door, she saw Wilson carry over a big tub and place it outside the window next to the fireplace. Next he came with a bucket of potatoes. He handed Donna the peeler before she could gather the sense to escape. "Now we'll be ready for dinner when Grandma gets back!" Wilson smiled, went inside and watched Donna peel potatoes from his favourite chair.

When Harriet returned from Church an hour later Donna was barely halfway through the bucket.

~~~~~~~

The old General Store is quite derelict. Donna's mother refuses to change anything for fear of ruining the old building. Vandals have smashed windows and scorch marks on the front doors are evidence of an attempt to set fire to the building in spite of the "No Trespassing" signs.

The teal paint on the old house seems to glow in the hazy late afternoon light. I figure if I wait long enough, I'll hear the store bell ring and the laughter of children picking up a cold bottle of pop and some jawbreakers before August ends and school begins again.

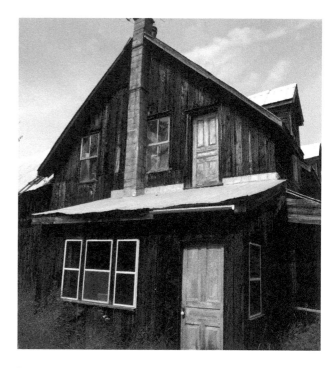

Swords, back of the building, 2010

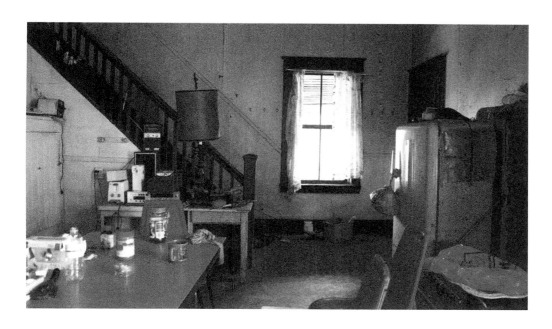

Swords, kitchen, 2010

Cooper's Shed
acrylic on canvas
8"x10"
Private Collection

Cooper's Falls

One of the most famous "ghost towns" in Muskoka isn't really a ghost town – yet – and neither is it entirely in Muskoka. Visiting Cooper's Falls is like driving through a window into the 1940s. At the top of a small hill two aged buildings sit across from one another, joined by a single strand of lights that swings across the road and twinkle multi-coloured after dusk. I drove down the Cooper's Falls Road in search of the famous General Store and the man who, at nearly ninety years of age at the time of my visit, was just retiring from the excavation business he ran for over sixty years.

The Cooper's Falls General Store closed in 1960 and both of the town's churches have since been abandoned, but the community still has a handful of permanent residents, resisting the status of ghost town. Frank Cooper, grandson of the founders Thomas Cooper and his wife Emma, happened to be on his porch that late August afternoon and when I walked up to say hello, Frank encouraged me to join him. He was sitting in a wooden chair on the screened in porch off the kitchen, enjoying his coffee and a sandwich with a friend. I grabbed a chair between them while the two men enthusiastically reminisced. As it turned out, this was only the first of what would be many visits

During my second visit, Frank was arranging gravel deliveries on the phone from the kitchen. He is slowly handing the reins over to Darren Bunker. Darren and his father were both longtime employees of Frank's company and now own and run the business from the courthouse across from the General Store. The courthouse is an unpainted frame building that has had a number of functions over the years; it was once a community hall, and has long been mistaken for a blacksmith shop. Frank's grandfather, Thomas, was the town's first magistrate, and regularly heard cases on the second floor of the wood frame building. He kept detailed notes on each case in his diaries, which also provided a record of the earliest days of Cooper's Falls. Unfortunately when Thomas retired, he had the diaries burned.

Frank was the youngest in his family and because of this low position he got shifted from one bedroom to another above the Store. His favourite was the front south corner; it had two windows and the sun warmed it in the afternoon on cooler days. As a boy, he could often hear the wolves howling in the dark out toward the

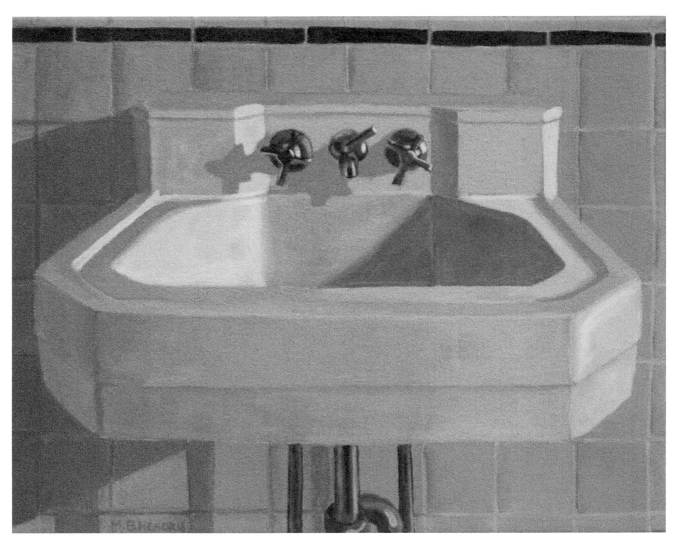

Mrs.. Cooper's Bathroom Sink, 2010
acrylic on canvas
8"x10"
Private Collection

Muskoka (Ryde) border. He and his brothers would sit quietly, wondering if the wolves were looking for them as they had once stalked his grandfather on a supply trip. Thomas had forgotten his rifle and was caught on the road at night. He had no protection from the wolves that, in the end, consumed his cow.

In front of the Cooper's Falls General Store are two pumps; one was for gas and the other for kerosene. On one particular delivery, the pumps were mixed up and the kerosene tank was filled with gasoline. Gas is much more volatile than kerosene and this caused a great deal of excitement around town. Many folks would use kerosene to get their stoves going in the morning; to get gasoline instead could result in a rather explosive surprise and, if one was very unlucky, a fire. More than a few curtains were scorched!

Frank was gracious enough to give me a tour of the entire General Store and the living quarters, offering anec-dotes about life in the house along the way. When I arrived an old oil furnace burned hot in the kitchen. The heat to the rest of the house was turned off as the kitchen and main floor washroom were the only areas in use. The build-ing was snaked with stovepipes no lon-ger in service. Many houses of this era were originally heated by this method, but this was also often the reason that numerous old frame buildings burned. This nearly happened to Frank.

~~~~~~~

One day when Frank had been left to mind the store while his mother was away, a fire broke out in the black stove-pipes running along the hallway ceiling on the second floor and through his mother's bedroom at the front of the house. When Frank smelled the smoke he tore up the stairs in a panic. The pipe running through his mother's room was red hot. Soaked with sweat, he ran down the hall to get water and threw it over the pipe. The room was awash with steam and black smoke began to leak through the stovepipe's seams. Another bucket of cold water and by a miracle, the house did not burn.

~~~~~~~

The stovepipes also functioned as a clothes dryer. A clothesline crosses the hallway at the top of the stairs running close to the stovepipe by Frank's moth-er's bedroom and blocking access to the rest of the second floor. One night many years after the fire incident, Frank was returning late from a date a little tipsy. He struggled with all his strength to make as little noise as possible. He

He and his brothers would sit quietly, wondering if the wolves were looking for them

could hear the delicate snores coming from the front room and he didn't want to get caught in his condition at this hour. He snuck up the stairs, wincing at every creak in the dark. He had to get past the clothesline, which he knew his mother had hung heavy with washing. But he couldn't see it and became entangled in the clothes. Trying not to panic or pull anything down, he spent the rest of the night in the hallway.

~~~~~~~

Near the end of the second floor hallway is a small pink-tiled bathroom that opens up to the left. It is no longer in use due to damaged pipes, but all the hardware is original. The room has no window and is lit by a single lamp. The choice of this

bathroom's sink as the subject of my painting might seem odd considering the vast number of great things to see at the Cooper's Falls General Store, but, as always, the mundane things struck a chord with me in this series: the objects that people used every day, the things they saw and that were a part of their lives and that we can, in many cases, relate to still.

An atrium at the centre of the building provides access to the rest of the residence but is also a room in itself. A big chair, a credenza full of pictures and an electric organ Frank's mother used to play, fill the dark space. Photographs of Frank in his military uniform, his mother's parents and his daughter covered the top. One photograph in particular of a small boy in overalls, proudly

**In the General Store, 2009**

58

holding a fish, stood out to me. The elderly man in my company seemed incongruent with the enthusiastic child looking straight out of Mayberry.

The entrance to the General Store is an unassuming wood door with a porcelain handle. Frank closed the store to the public in the early 1960s and left everything pretty much in place: an old sock mender still in its original box, the weigh scale, the cheese cutter, the paper rack; even the old postal boxes still hang on the wall. The original sales slips are still in the drawer, the phone number was a single digit and a transfer.

I looked up at the ceiling toward the single bulb that lit the space and followed the wires around insulators of exposed knob and tube wiring. A folding seat is attached to a support pillar inside the store near the door. Frank said an old Boer War veteran used to sit there for hours on end and tell him stories.

From high on a shelf beside the post boxes, Frank pulled down his old hockey trophy – made from a sap bucket – that Cooper's Falls had won against Washago in 1929. Competition between the two communities was fierce and playground friendships were no barrier to the

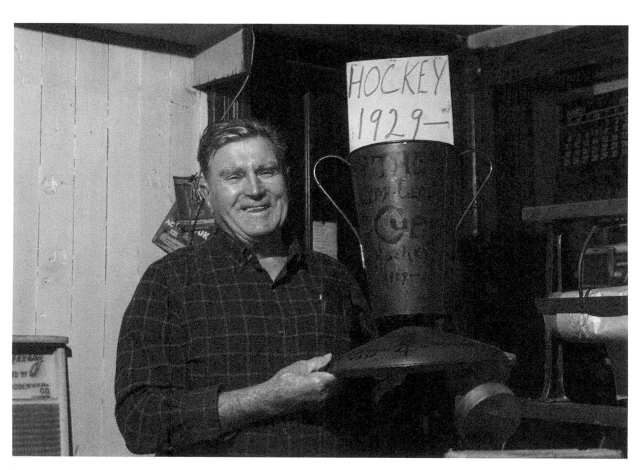

**Frank Cooper with 1929 Hockey Trophy, 2009**

quest for hockey victory. Even Frank's favourite girlfriend was the enemy during hockey games. As the tour was coming to an end, Frank and I returned to the warmth of the back kitchen. I sat on an old couch that now occupies the place where the hand-operated water pump used to come into the building. Next to this is a window that overlooks the garden; the window is flanked by two electric lights designed to look like the lanterns. In Frank's mind, they were still lanterns. Sipping his coffee, Frank shared one of the few memories he had of his father.

~~~~~~~

Frank was two years old, and he loved to watch his father sharpen his razor on the long belt that hung next to the kitchen window. Frank would mimic his father's strokes in the lantern light, watched through the corners of his father's eyes. That same year he heard the kitchen door thrown open and men yelling in the distance. It was an accident at the Mill. He never saw his father again.

~~~~~~~

A small window lets in the November chill, animating the curtains in the hall. Steam rises from one last pot of coffee before the heat is claimed by winter's grip of ice and snow.

**Light string crossing the road, 2009**

Scale from General Store, 2009

Kerosene Pump, Cooper's Falls, 2009

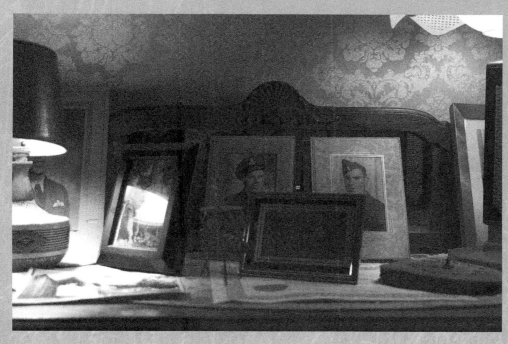

Family photos, 2009

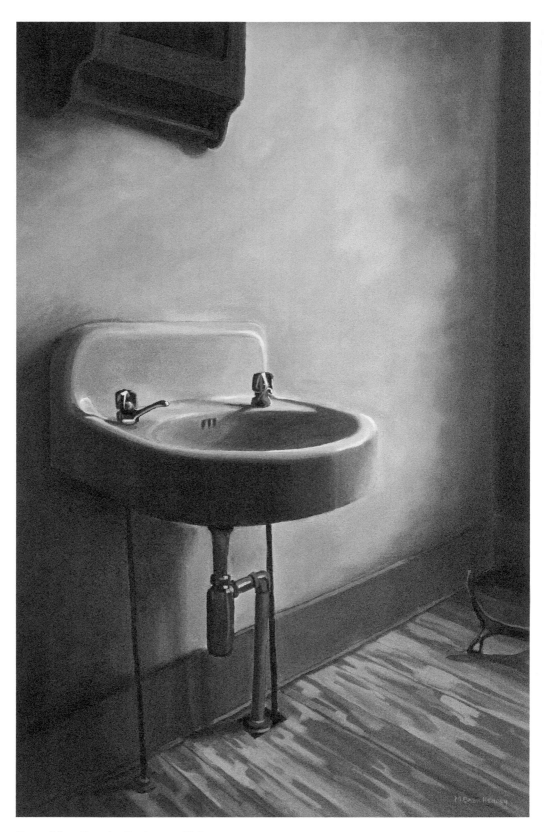

**Everything But the Bathrrom Sink**
acrylic on canvas
24"x16"

# Everything But the Bathroom Sink

Steam softens the corners of a small room cast pink by vinyl curtains diffusing the grey light of early December. The white porcelain tub seems to float in the mist, held aloft by the claws of lions; the sink appears suspended. Water drips onto the floor and follows the grain until swallowed by the dry wooden boards.

I often have music playing in the background while I paint. While I was working on "Everything But the Bathroom Sink," I played songs over and over which captured the feeling I often encounter in the old houses I visit: loneliness with an underlying warmth and spark of light that permeates the darkness just as an underground stream fills the cracks of a cave.

One of my favourite pastimes was to walk around my neighbourhood in Gravenhurst, a town famous for its two lakes, sawmills, wooden boats, the century-old steamship Segwun and the first tuberculosis sanitarium in Canada. The town is quieter in the early twenty-first century, its main street plagued by recent fires and repeated shifts in economic prosperity.

On my walks I often passed by an old nineteenth-century Ontario vernacular house, occupying a double town lot not far from the cemetery. It intrigued me,

out of place in a neighbourhood composed largely of modern homes. The house sat vacant, and I watched as the porch sagged a little more each year. In the history books, it appears in photographs surrounded by fields near the old sanitarium/prisoner of war camp that once sat on the shores of Gravenhurst Bay.

At one of my exhibitions, Marion Fry, once a caregiver at "the San," talked about the surprising history of tuberculosis in boarding houses in Gravenhurst. I wondered if this once isolated property that had been so close to one of the sanitariums in town might have been one of those houses that took in tuberculosis patients? According to reports from the period, there were more than one of these kinds of places in town and they were a public health concern for the local council. Some boarding houses took in patients in the advanced stages of the disease, though in some cases, they were unaware that their boarders were ill. *

Gravenhurst was the first community in Canada to have a sanitarium for the treatment of tuberculosis (TB). Three different locations operated throughout the north end of town from the 1880s

* *Annual Report of the Provincial Board of Health of Ontario,* Vol. 18, 1899 (Warwick Bros. and Rutter, 1900), p. 72.

through until the 1960s, when advances in medicine made them obsolete. From the early 1920s, part of the complex was operated in a new brick building named for the philanthropist William Gage, who built the first sanitarium in 1897.

Before the existence of antibiotics, TB was most commonly treated with "fresh air"; however, treatments such as pneumothorax, drastic surgeries and lobectomies were also performed, along with other invasive procedures. Some of these treatments were advanced by none other than Dr. Norman Bethune, once, himself, a patient of the sanitarium and well known for his humanitarian work in China. TB is most commonly associated with a cough, but the disease invaded other organs including the kidneys, the bowels and even the spine.

Life at the sanitarium was bitterly cold much of the year. Windows were kept open almost all of the time, even on the coldest winter nights. The sounds of the "TB cough" could be heard throughout the wards. Most patients struggled to breathe as the disease filled their lungs with fluid, slowly drowning them. The risk for those who worked in the hospital was high and many townspeople saw both the staff and the patients of the sanitarium as a threat – carriers of a deadly disease from which even some survivors never fully recovered. Death was a constant companion to the afflicted, courting them one

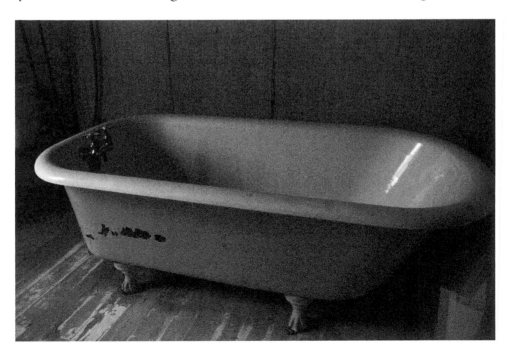

The original bathtub, 2009

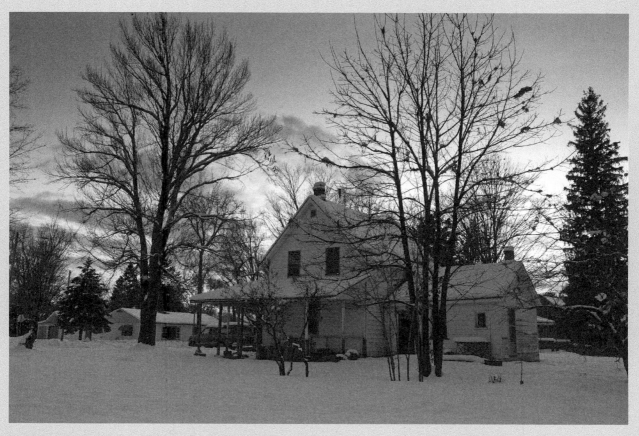

**Before renovation, 2009**

painful breath at a time.

With the help of the Judy Humphries at the Gravenhurst archives, a search was done, but no specific properties in town could be identified as boarding houses with any certainty.

In 1929, the old farmhouse was purchased by Morley Heels and was home to his family and his oil delivery service. It remained with his daughter, Isabel, until shortly before her death in 2011 when it was sold to new owners and renovated.

~~~~~~~

The windows were open on the snowy December day of my first visit inside the house. The winter white of the roofs outside made the dark wood of the rooms deeper. The house was silent, without even the hum of electric lights. The silence was so profound that snowflakes landing on the windowsill seemed to make the sound of shattering glass.

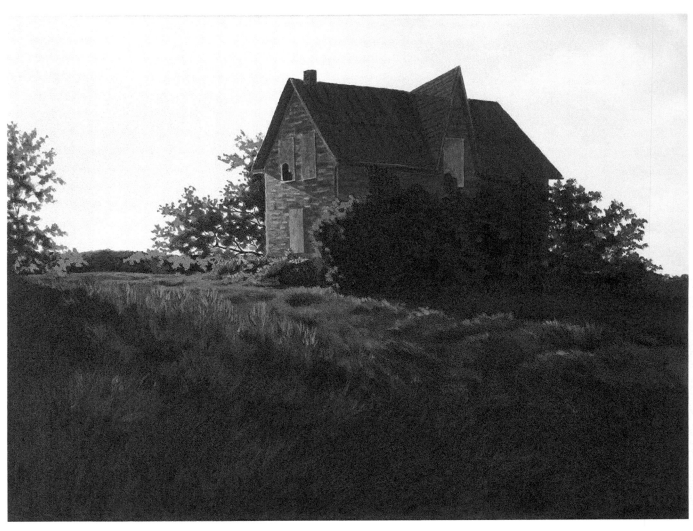

Afternoon Light at Lavender, 2009
acrylic on canvas
18"x24"
Private Collection

The curfew tolls the knell of parting day,

The lowing herd wind slowly o'er the lea,

The plowman homeward plods his weary way,

And leaves the world to darkness and to me ...

For thee, who mindful of th' unhonour'd Dead,

Dost in these lines their artless tale relate;

If chance, by lonely contemplation led,

Some kindred spirit shall inquire thy fate ...

~ from Thomas Gray's
"Elegy Written in a Country Churchyard"

Bibliography

Annual Report of the Provincial Board of Health of Ontario, Vol. 18, 1899, Warwick Bros. and Rutter, 1900.

Boyer, Robert J., *A Good Town Grew Here: The Story of Bracebridge*, Bracebridge, Oxbow Press, 2002.

Hind, Andrew, and Maria Da Silva, *Ghost Towns of Muskoka*, Toronto, Natural Heritage Books (Dundurn Press), 2008.

McCraw, Bruce, *See You Next Summer: Postcard Memories of Sparrow Lake*, Toronto, Natural Heritage Books (Dundurn Press), 1998.

Rogers, John (maps) and S. Penson (sketches), *Guide Book and Atlas of Muskoka and Parry Sound Districts,* 1879, Toronto, H. R. Page, 1879, reprinted Boston Mills Press, 2000.

Sims, Diane, *A Life Consumed: Lily Samson's Dispatches from the TB Front,* Sudbury, Your Scrivener Press, 2008.

Tatley, Richard, *The Steamboat Era in the Muskokas*, Vols 1 and 2, Toronto, Boston Mills Press, 1983.

Veitch, Kenneth Carman, *My Early Days as Boy in Ufford*, self-published, 2009.

Acknowledgments

None of these stories would have been possible without the help of the families, local historians and their legacies. I would like to thank the following for sharing their time and their histories with me: the late Elva Bowes, Don Bowes, Frank Cooper, Connie and Doug Cassin, Marion Fry, Shawn Gallaugher, Bernice Gillies, Donna Haslehurst, the Venerable Dawn Henderson, the late Tom Iddison, Curtis Iddison, Bruce Johnson, Teresa and Winifred McLaughlin (Auburn Gallery), Jennifer Milne, Jane Morgan, Walentina Rodak, Bill Shea, Stanley Socha, Judy Veitch and Ken Veitch, and Judy Humphries of the Gravenhurst archives.

I thank Laura Cameron, Kevin Nunn and Michele Rackham Hall for whose assistance in editing this book over its various incarnations, I am extremely grateful and Paul Bennett for his excellent photos of many of the paintings in the book. Thanks to Bev McMullen for her encouragement and for being a kindred spirit wandering through ancient hallways; and to Patrick Boyer for encouraging me to see the project through.

See more at www.mhendry.com.

About the Author

M. (Michelle) Hendry, B.A., SCA, is an award winning artist, writer and designer, a member of the Society of Canadian Artists and a founding member of the Arts Council of Muskoka. She instructed at Georgian College in Design and was an entrepreneur in the field of graphic design for over a decade before turning to fine art full time. Michelle kept a blog beginning in 2007 recording her artistic journey and the search for history through art that became *Once Imagined*. Michelle has work in private collections in Canada, the U.S., and the UK.